By JOHN HAWKINSON

A BALL OF CLAY

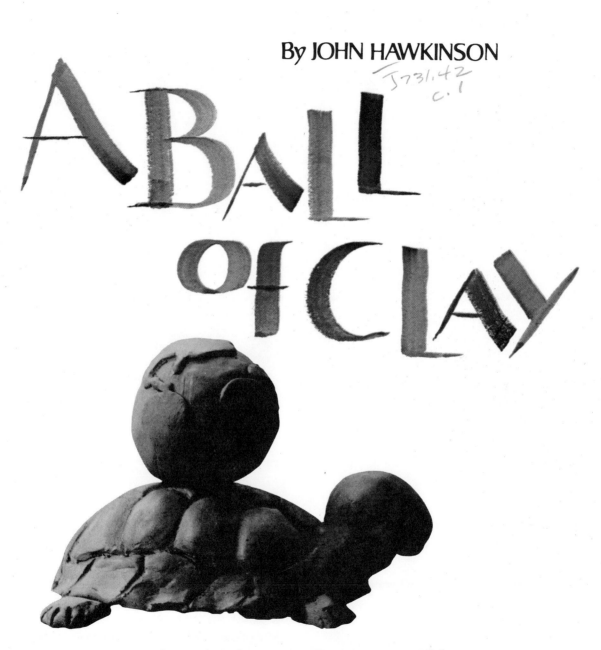

Albert Whitman & Company · Chicago

Library of Congress Cataloging in Publication Data

Hawkinson, John, 1912-
 A ball of clay.

 (Collect, print, and paint series)
 SUMMARY: Introduces clay as an art medium
with information on how to find it in nature, prepare
it for handling, and use it to create a variety of non-
permanent projects.
 1. Modeling—Juvenile literature. [1. Clay
modeling] I. Title.
TT916.H38 731.4'2 72-13350
ISBN 0-8075-0557-9

CLAY AND CREATIVITY

Before talking about how to use clay, let me acknowledge the cooperation I received from the Lawrence Library and the Lawrence, Michigan, Elementary School. The principal, her staff, and the teachers with whose classes I worked were all most helpful. The children were delightful to work with, and they fulfilled my wildest expectations with the things they made in clay.

Personally, I don't believe in talent, competition, or production, but I do believe in the ability to be creative. I was allowed to work with the children with this in mind. At the end of each class, everything was squished up and the clay put back into the pot. The children were always neat, and cleaned up willingly, as all artists should.

We were able to concentrate on learning. Because I was not part of the teaching staff, I did not have to give grades. And clay being the way it is, we made a lot of mistakes, which of course with clay are not really mistakes. The children were very patient with me, and when I tried to teach

them things that were too difficult or not appealing, they tried hard before suggesting something else to do.

I find that you can say "play with clay" or "work with clay" just as long as the children get to use clay. But most children if left alone to choose what they want to make will do lumpy ashtrays or snakes. This is not a kind way to treat kids—it bores them.

I show children how to use their hands as tools for molding, shaping, and smoothing clay. I believe that if the hands are used together, the object will be naturally symmetrical.

This book which grew out of work with children is designed for the abilities and desires of youngsters in the first three grades. But the same principles of rhythmic motion and symmetry apply at any age. So does the idea of destroying your work for the first hundred items. If you must, things can be fired and glazed. This pleases adults, but to most children it means very little. A child just wants to have more clay to use, and it is enough to fire things just once a year.

The objects children make in this book illustrate the use of the hands and a few tools rather than how to make this or that. I ask children to try to use their hands together or to hold their tools as I show them. I believe that all children can be creative and do things in clay that they really like. They need, however, to learn how to use their hands and tools, and of course they should not have to compete or progress or make a permanent product.

Given a choice of art media, I have found that children will invariably choose clay. This is because children are smart. Clay is a two-handed medium. It is completely malleable, changeable, and it cannot be destroyed. It is the least expensive medium, nonpolluting, easy to keep, always ready, and the most fun.

The reasons why clay is not used as extensively as it should be are many. None is valid. So—get some clay. Only a few of us cannot afford to buy clay. Those unfortunate few will have to find a creek to wade in, hunt for a bank of clay, and carry some home. Of course, if you go hunting for clay you must leave your children at home. After all, who's ever heard of a child who likes to wade in a creek? You say all your children would love this? Fine! So do mine. Now let's begin.

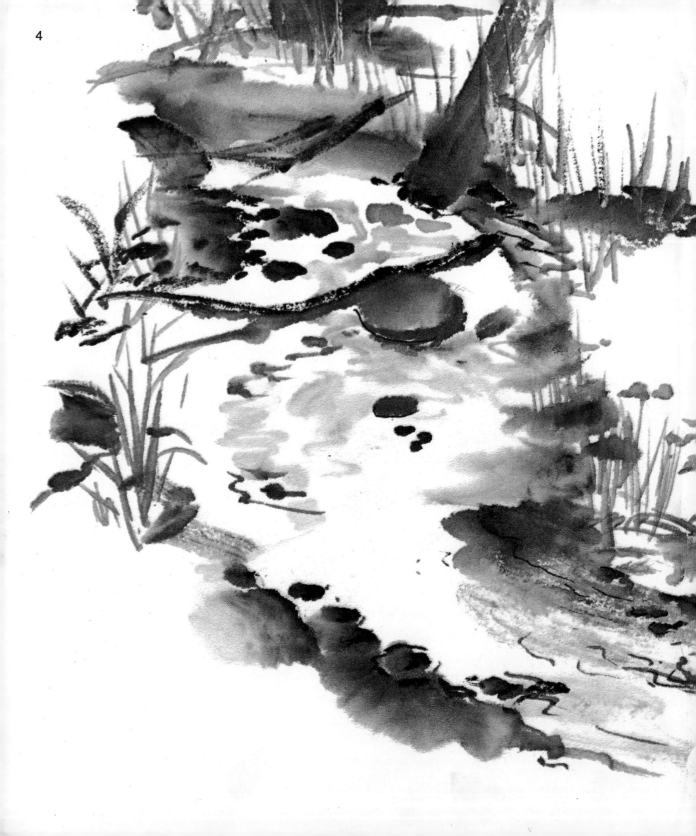

STARTING

Finding Your Own Clay

A creek as it goes flowing along cuts through the topsoil to expose what lies below.

Follow the creek as it runs over gravel and around stones. Wade through little pools with sandy bottoms. Keep looking, and you will find a bank of clay. It comes in many colors, but you are most likely to see gray or buff clay.

The best way to carry clay home is in plastic bags, which are nice to have along just in case you find something interesting on any walk.

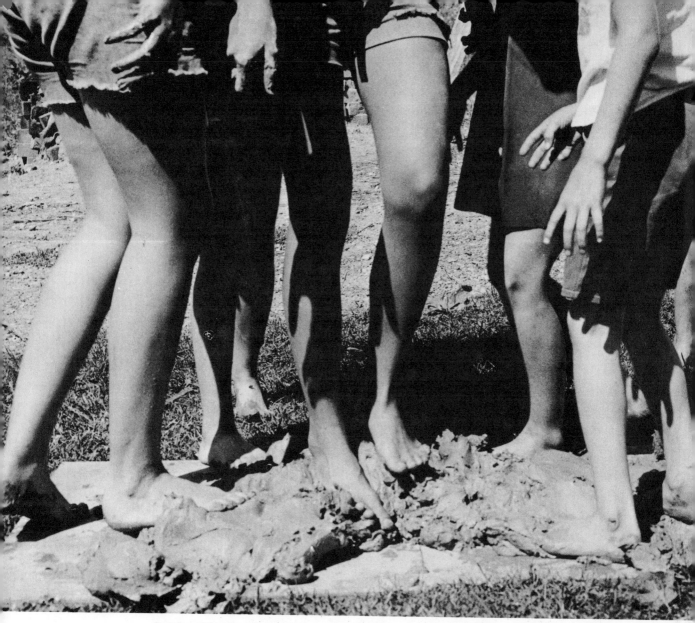

Getting Clay Ready to Use

When you get home with your clay, take the stones out and knead it—turn it and press it.

If the clay is too hard to knead, here's what to do. Put the clay in a vessel, such as a pail, and cover it with water. Stir the clay until it is soft and soupy. Let it stand until the clay settles and clear water forms on top. All of this may take several days.

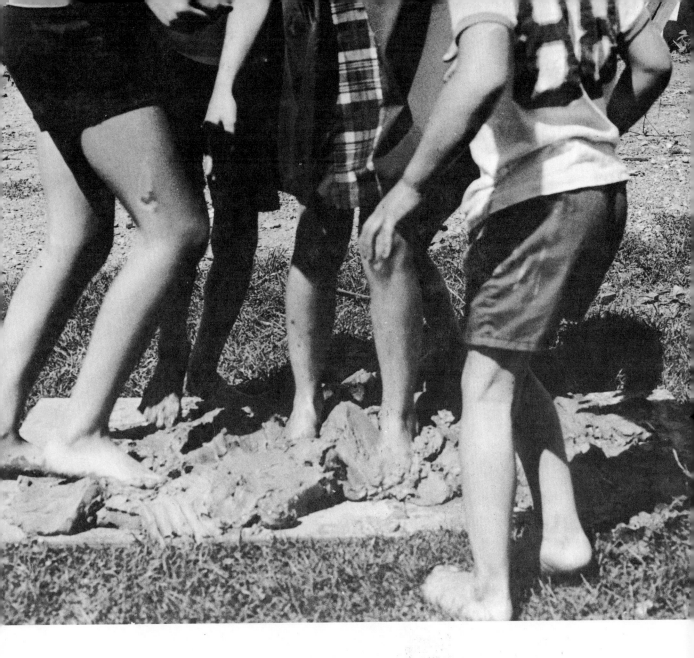

Pour the water off and scoop the clay out onto a flat board to dry. When the clay is dry enough to knead (in about a week), store it in a closed container.

If you have lots of clay, put it on a big board and knead it with your bare feet. This is the best way, and it's fun, especially when you do it with your friends. How else can you use your feet, except for walking or running?

If you can't possibly get to a creek, look for a place where a road is being built or a foundation for a building is being dug. Usually you can find great gobs of clay.

If worst comes to worst, you may have to buy your clay. This is not as easy as it seems. People may try to sell you clay mixed with oil, called plasticine or modeling clay. Or they may try to sell you something made from flour. Pay no attention. Insist on regular, ordinary clay, sometimes called potter's clay.

The moment you get the clay home, remove it from the plastic wrapping and put it in an air-tight container. Keep a damp rag over the clay and the lid well closed. Then your clay will always be ready to use.

When Clay Is Ready to Use

Clay that is ready for use should be dry enough so that it won't stick to your fingers. It should be moist enough not to crack or crumble.

This clay is too sticky to use. Roll it on paper to take out some of the moisture.

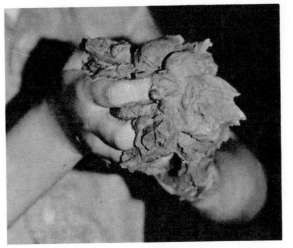

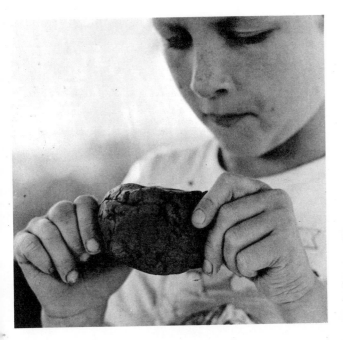

This is clay that is too dry to use. See the cracks? Throw it back in your container and get another lump. If you add water to this clay, it will get messy. Then someone may get mad at you and take the clay away.

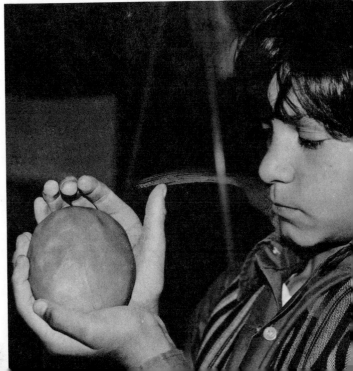

This is clay that is just right. It feels good in the hands, and it is easy to work.

Take a good lump of clay, as big as your fist. Hold it in both hands and pat it and pat it until it is nice and round.

Sing along while you work—"Patty-cake, patty-cake, baker's man." It's always more fun to do with friends and classmates.

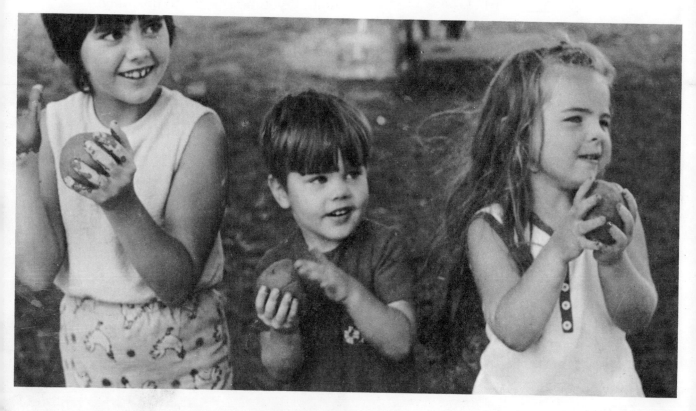

When you're sure your ball of clay
is nice and round, drop it from way
up high to the table or floor.

Pick up the clay and turn it over
and pat it with your hand.

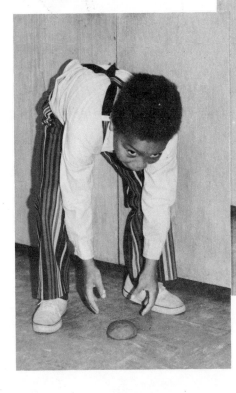

Pat it and pat it, just like a drum.
About six or seven pats will do.

Now pick the clay up and
flip it over to the other side
so that it won't stick
to the table.

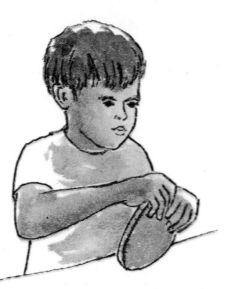

Pat the clay again and pat it some more. Keep patting
and flipping until your clay's a nice smooth pancake as
thick as a pencil.

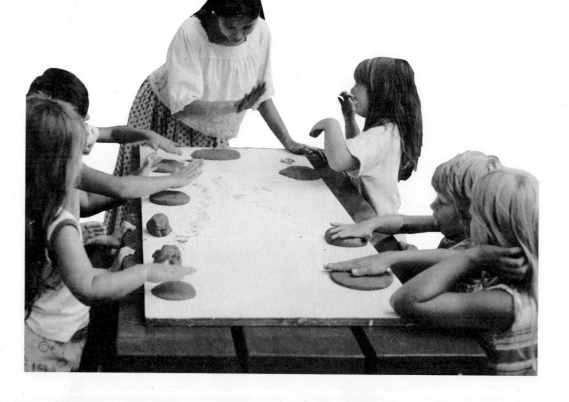

MAKING BOWLS

Pick up the clay pancake
and place it on your knee.

Smooth it down with
your hands.

Lift the clay off your knee and turn
it over. Look! It's a bowl.

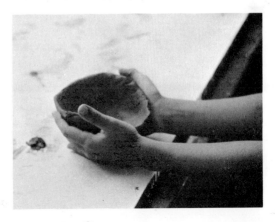

14

A Bowl That Won't Tip

A bowl with a round bottom tips over easily. This won't happen when a bowl has a footing.

Take another ball of clay and pat it and flip it until you have a pancake.

Take a smaller lump of clay. Squeeze it in your hands until it is long. Put it on the table and roll it gently with your hands. When it's as long as both hands . . .

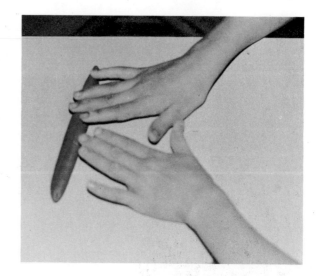

make a ring like this.

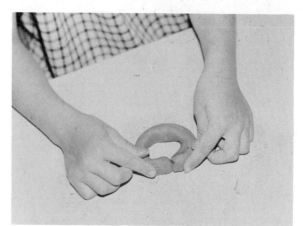

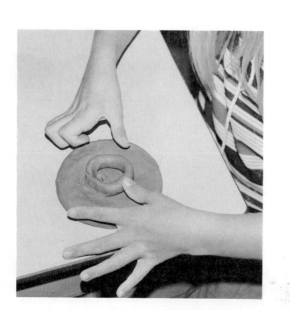

Place the ring on the clay pancake and press down on the inside and outside of the ring to make it stick.

Just as you did with your first bowl, pick up the clay pancake and place it on your knee. Be sure the side with the ring is up. Press the pancake down. The ring may need a little more pressing, too.

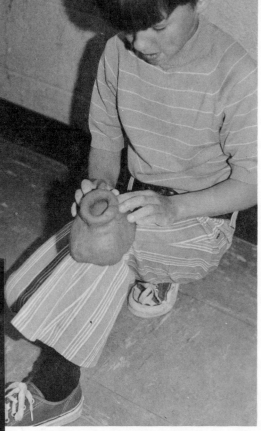

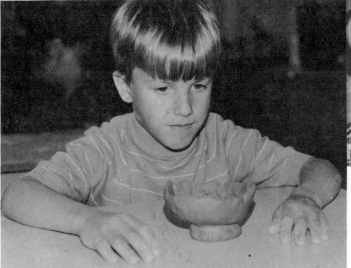

Pick up the bowl. Turn it over and put it on the table. It doesn't tip, does it?

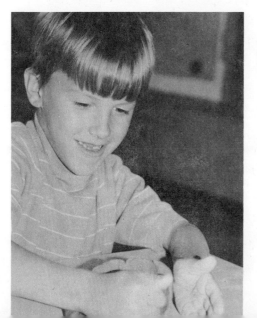

Now crunch the clay up so that you can use it over again.

More Bowl Shapes

Look around. What can you use to shape a new bowl? Make another ball, a round, smooth one. Hold it up high and let it fall. Pat it and pat it and then flip it over and pat it some more.

Try your clay pancake on your fist. Try it on your foot, your elbow, or even someone's head—with a paper towel first to keep the clay from sticking. Each bowl will be a little different.

What about fruit and vegetables?

An apple or an orange is a nice round object for shaping clay. Rub some soap on the fruit first so that the clay pancake won't stick.

An acorn squash is my favorite. It makes such a beautiful bowl. Press the clay gently, cover only half the squash, and take the clay off right away. If it happens to stick, peel the clay off and start all over again.

When you make an apple bowl, don't forget to wash the soap off the apple before you eat it.

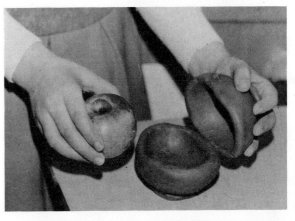

Here's an apple bowl with a cover.

TOOLS

Hands are the best of all tools for working with clay. But it's nice to have tools for cutting and digging. Fortunately these are easy to make.

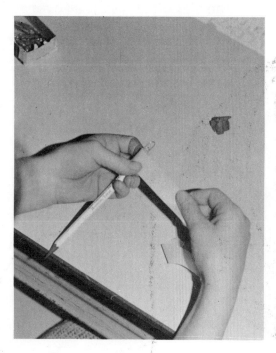

Here's a tool for digging or gouging. Make it by taping a paper clip to a pencil, like this.

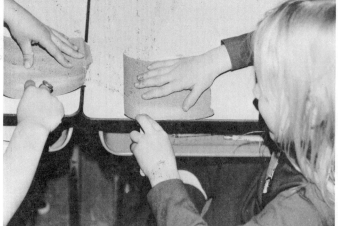

Digging Tool

Cutting Tool

Pressing Tool

To make a cutting tool, sand a popsicle stick or a small piece of wood until it has a knifelike edge. Sand the other end square to make a pressing tool.

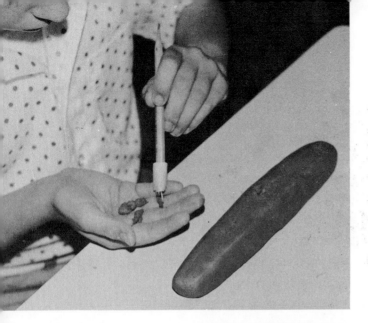

Using Your Tools

Here's one way to use the gouging tool. Keep all the little pieces you dig out in your hand or in a pile. One little piece of clay dries very fast, and if it falls on the floor it will make a mess.

Hold the cutting tool firmly, straight down as in the picture, and you can cut many shapes in clay.

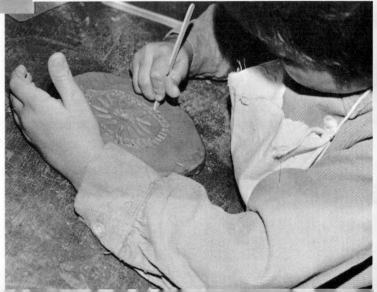

The other end of the cutting tool is for pressing designs.

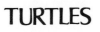

TURTLES

A turtle's shell has a beautiful
design. Look at a turtle or a
picture of one and count the thirteen
sections of its shell. This makes a
good design to press into clay.

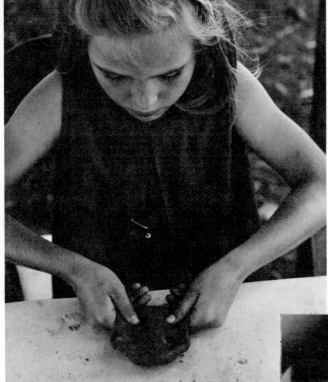

Making a Turtle

To make a clay turtle, drop a ball of clay from as high as you can reach.

Pick up the clay and turn it over. Make legs by pressing with your thumbs, like this.

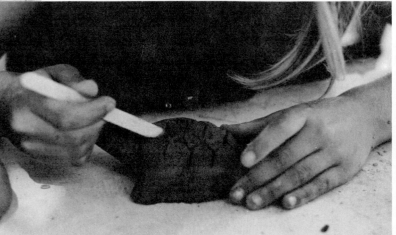

Turn the clay over. Add the head. Then make the design on the turtle's back. It is easy if you start with four lines in the middle of the shell.

Of course there are other ways to make a turtle. Here's a shell being fitted on top of a turtle body. You can also fit the clay over your knee and make a turtle that way, too.

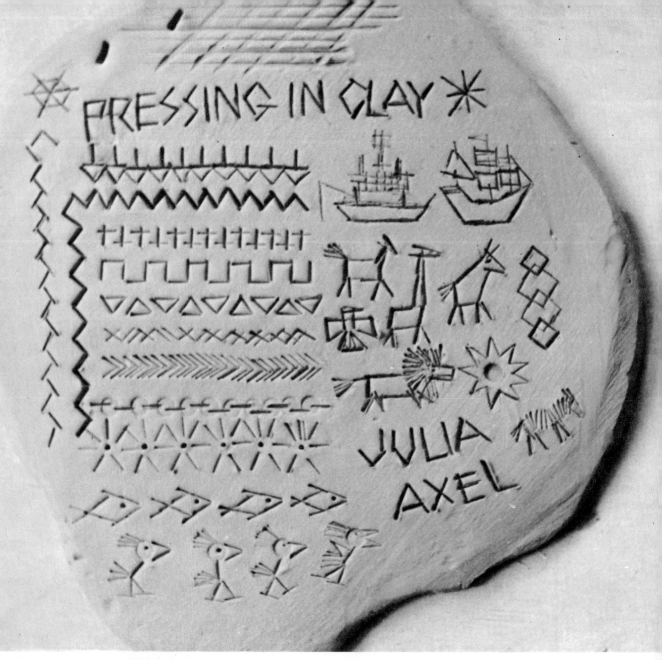

DESIGNS

A turtle shell is just one design from nature. There are many more. And there are other designs from all over the world. These can be pressed in clay with the tools you made. Make a pancake and press away, making a pattern over and over if that's the kind of design you want.

Try pressing and drawing on clay. Pressing, you will see, is much better than drawing.

You can press a design into clay in another way. Look for something to roll over it, like this pine cone.

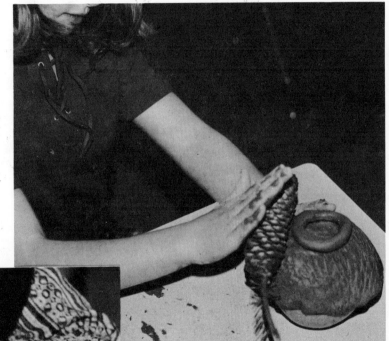

With your cutting tool you can cut flat shapes from clay and then press designs on them.

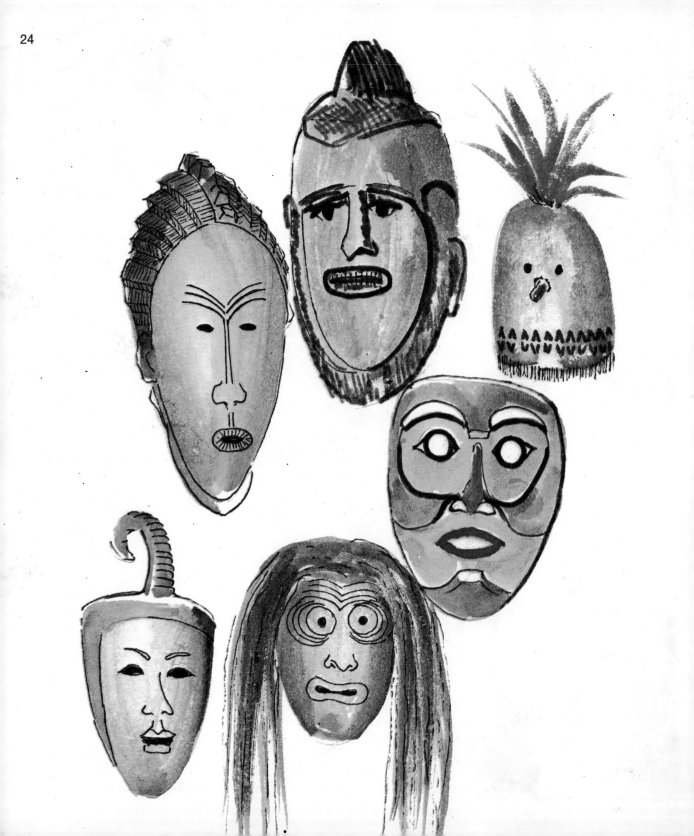

MASKS

Masks are made of many materials
by people all over the world.
Masks are used for many purposes,
and sometimes just for fun.

How to Make a Mask

To make a mask, begin with a lump of clay. Pat it into a ball, or an egg shape if you like. Drop it and pat it and flip it until it's smooth and thick as a pencil.

Put the clay over your knee and gently smooth it down.

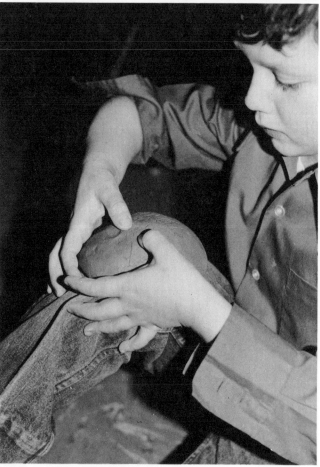

Make the eyes in your mask by pressing down with both thumbs at once. Keep your thumbs not too close and not too far apart.

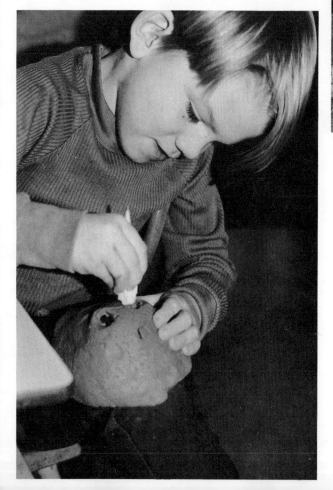

You can dig out the eye holes if you wish, using the digging tool you made. Save the pieces for the nose.

Feel the shape
of your own nose,
like this. It is a wedge.

Press together the clay you saved when you made the eye holes and add more clay if you wish. Press and smooth first with a finger on each side and then with both thumbs on the bottom. Keep the mask over your knee as you work.

Just below the nose, cut an opening for a mouth. Don't make it too big or the mask may fall apart.

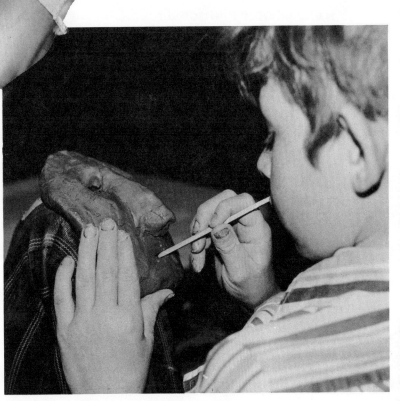

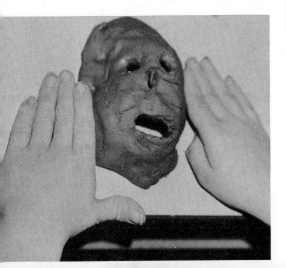

Put the mask on the table. Try changing the expression by pressing the sides or opening the mouth. If you decide to add anything or do more cutting, put the mask on your knee to hold its shape.

DIFFERENT SHAPES

All around us are houses, tall buildings,
boxes, pyramids—shapes of many kinds,
some smooth and some rough.
These shapes can easily be modeled in clay,
and you can make up your own
interesting shapes, too.

Making Shapes with Clay

Start with a cube. Take a lump of clay and make a ball. Drop it on the table. Pick it up, turn it, and drop it again.

Keep doing this, and pretty soon you will have a cube.

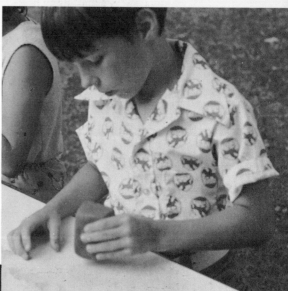

Take another ball of clay. Drop this one end first until you have a pyramid with a flat base and slanted sides.

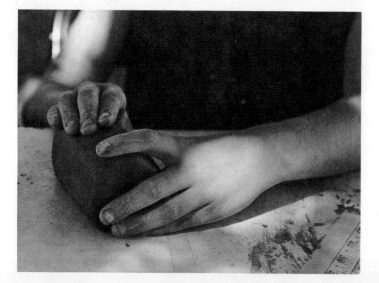

Pick up the clay and drop it again, this time at an angle to make a slanted roof. Now you have a house. With your digging and cutting tools you can add details like doors and windows.

Adding Designs

Try pressing designs on the shape
you have made.

With classmates or a friend, make shapes and put them
all together. Maybe you'll have towers that lean toward
each other or perhaps you will make a little village.

MUGS

I like mugs—
big mugs,
tall mugs,
small mugs,
any kind of mug.
They are fun
to make.

Making Mugs

Begin your mug by making a clay pancake (page 12). You are going to cut a slab with straight edges from your pancake.

Lay a ruler or piece of wood with a straight edge on the clay. Hold it firm. Cut with the hand you write with—zip! in one stroke.

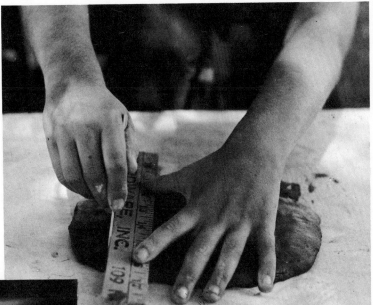

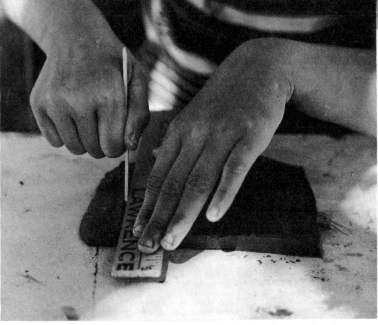

A square piece of clay will need three more cuts, this way.

Pick up the clay and turn it so that the next cut will be made with your hand in the position you used for the first cut.

Do the same for the third and fourth cut.

Of course you can move your hands around and cut the clay without lifting it up. But doing this is harder than you think, and your slab will not always come out square.

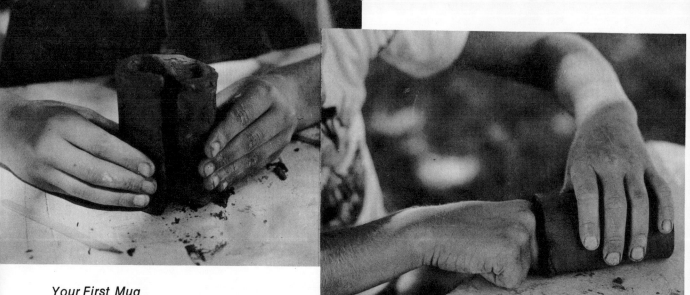

Your First Mug

Stand the slab of clay on an edge and gently bring the ends together. Butt the ends without overlapping them to make a neat seam.

Very gently smooth over the seam on the outside. Then lay the cylinder down with the seam on the table and smooth the inside.

Your mug will need a bottom. Make a ball of clay small enough to drop down the hollow cylinder.

Flatten the ball until it is a little too large for the cylinder, then wheel the disk over the table until it's small enough to fit just right.

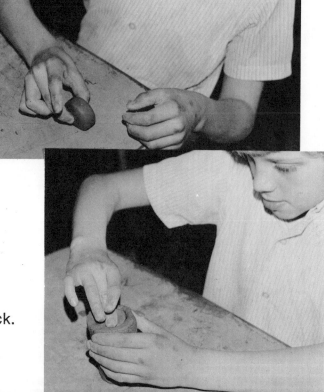

Fit the bottom into place. Gently smooth over the crack. Turn your mug over. Presto! Your mug is finished.

You can add a spout
and make your mug
into a pitcher.

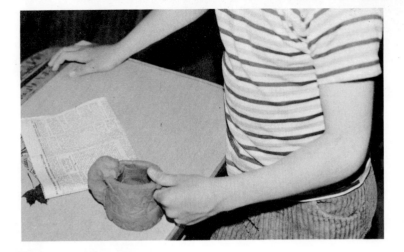

You can add a handle,

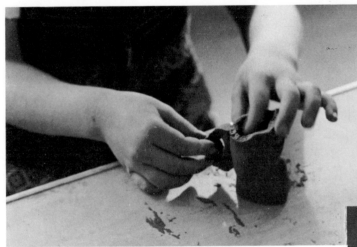

or a lid, if you like.

And then you can start
all over with a new mug.

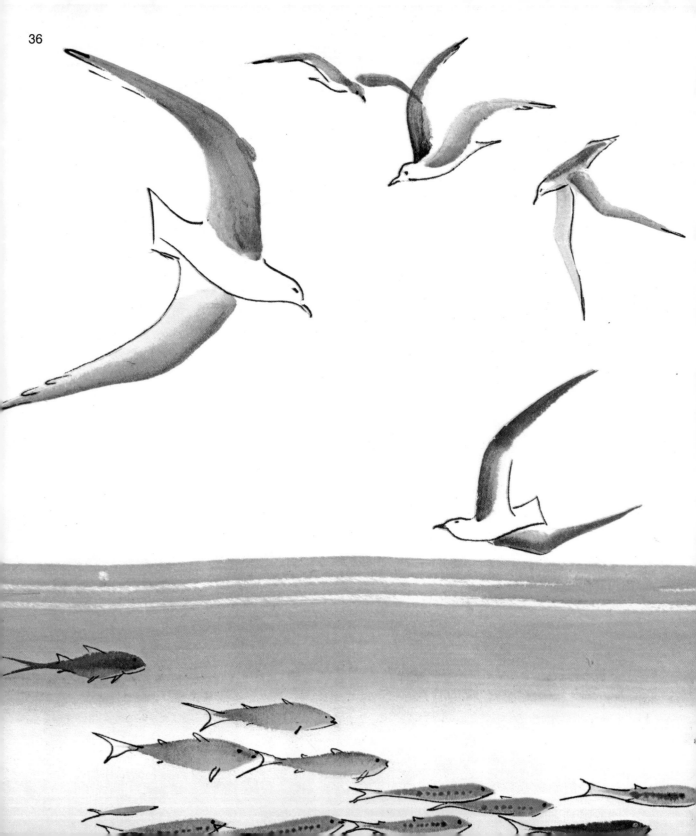

BIRDS AND FISHES

Fly like a bird!
Swim like a fish!
Maybe you can't do this, but
you can make a bird that looks
as if it could fly, and a fish
that looks as if it could swim.

How to Make a Fish

Take a lump of clay and squeeze it and turn it in your hands until it is shaped like a sweet potato. Lay the clay on a table and roll it smooth and pointed at both ends. If you don't happen to have a fish to look at, find a picture of one. See how smooth and streamlined it is? Look at the fish you are modeling. Point one end toward you and see if both sides are the same.

If the sides of your clay fish are not alike, work on both at once with the same motion. You can even put in the eyes at the same time by using two pencils.

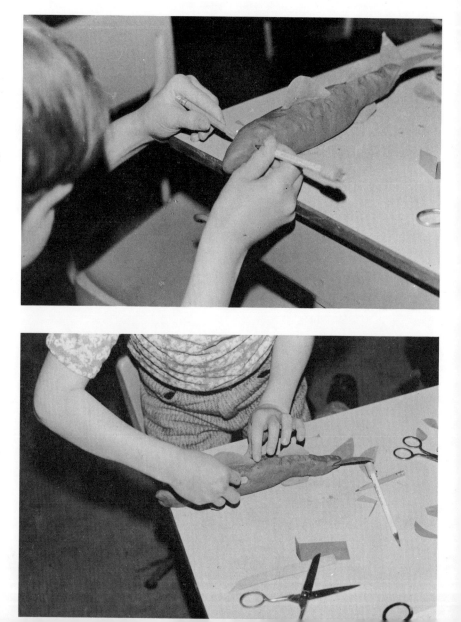

You can make the fins and tail by gradually smoothing the clay with your fingers or by cutting slots and inserting flat pieces of clay or shapes cut from cardboard.

Use your popsicle tool to press scales on your fish.

How to Make a Bird

For a bird, roll the clay
as you did for the fish.
Make both ends pointed.

Matchsticks make good
legs for birds. Push the
sticks into another lump
of clay to make your bird
stand up.

Cut two wings from thin
cardboard or construction
paper. Make slots in the
clay with your cutting
tool and push the wings
into the slots.

Make your bird fly
and soar in the air,
dipping and rising.

ANIMALS

Animals come in all sizes. They live everywhere
and are interesting to know. Take a good look at animals
of different kinds. They are not very hard to make in clay.

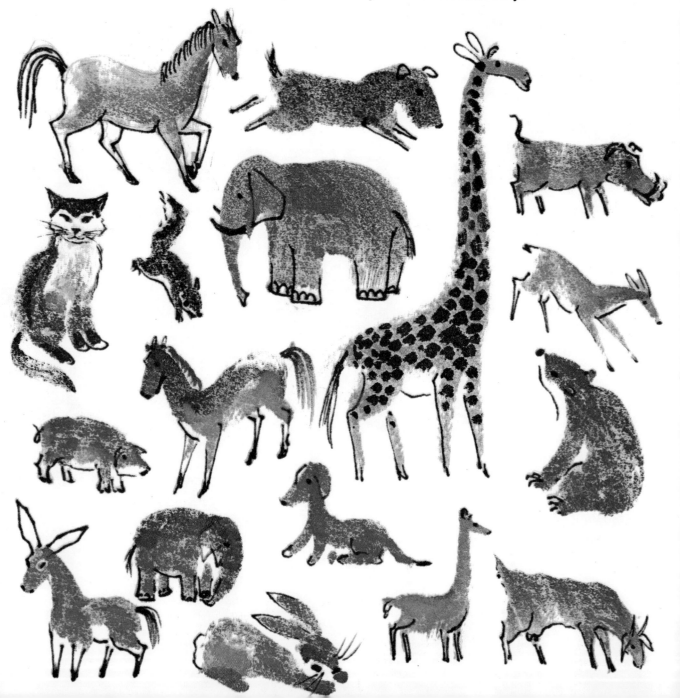

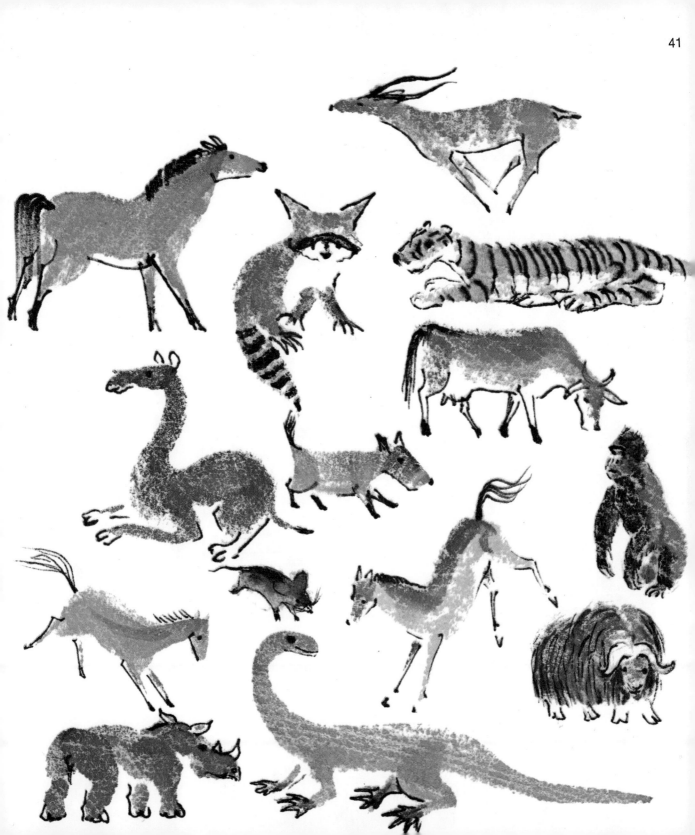

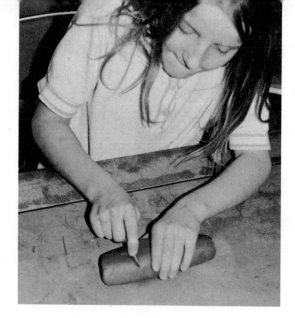

Now Try an Animal

Begin an animal by rolling a cylinder of clay. Cut off a piece for the head and neck and put it aside.

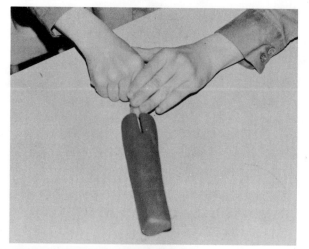

Make a cut at each end of the cylinder for the legs.

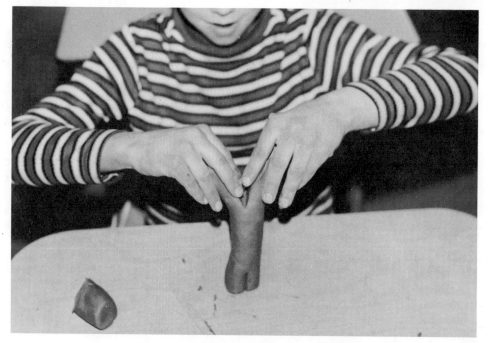

Work with both hands at once and round the legs. Try this with your eyes closed and you'll find that your sense of feel is good for sculpturing.

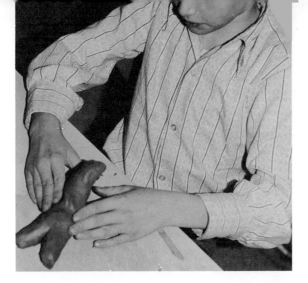

Smooth and press the head and neck with both hands, one on each side of the animal. Try closing your eyes as you work.

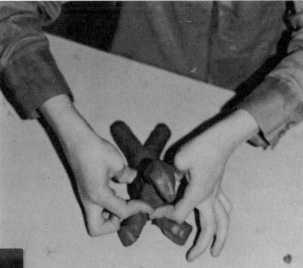

Don't bend the legs, but keep the animal body flat on the table when you attach the head. This keeps the legs from being bent out of shape.

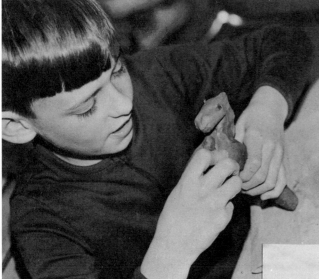

When your animal looks and feels symmetrical, it is time to bend the legs down. "Symmetrical" means that the left side is like the right side of the animal.

Stand the animal up and make a few finishing touches. Perhaps you can add a tail, ears, or press a design on the surface.

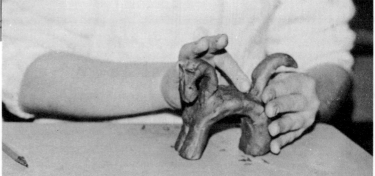

DOLLS

People (and children, too) all over the world make dolls. All kinds of materials are used, straw, wood, cloth, and clay.

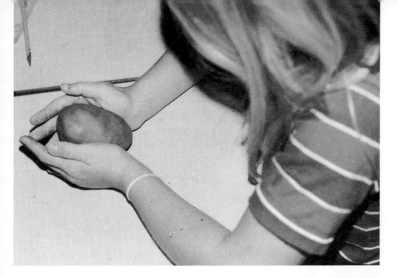

Make a Doll's Head

Here's how to make a doll's head. Start with a smooth, egg-shaped lump of clay. Set it on a neck.

In the center of the clay egg, press in the eye sockets. Do this the way you did when you made a mask (page 26).

Add a small piece of clay for the nose. Use your fingers to form the wedge shape. Look at someone's nose and feel your own nose while you make the doll's nose of clay.

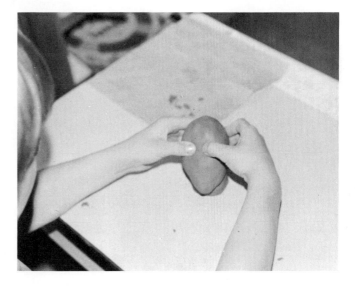

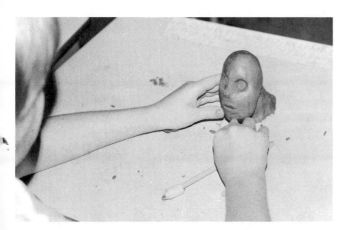

Add tiny pieces of clay for the lips. Look at lips and feel your own while you work with the clay.

If you wish, hair can be made from clay or yarn.

Turn back to the pages about making animals. You can use the same steps to make a doll's body.

RACING CARS

Racing cars are a good thing to design in clay. You can start with a cylinder, as you did for a fish, or you can begin with a brick shape. Use your digging tool to make the cockpit.

Make wheels as you made the bottom for a mug (page 34).

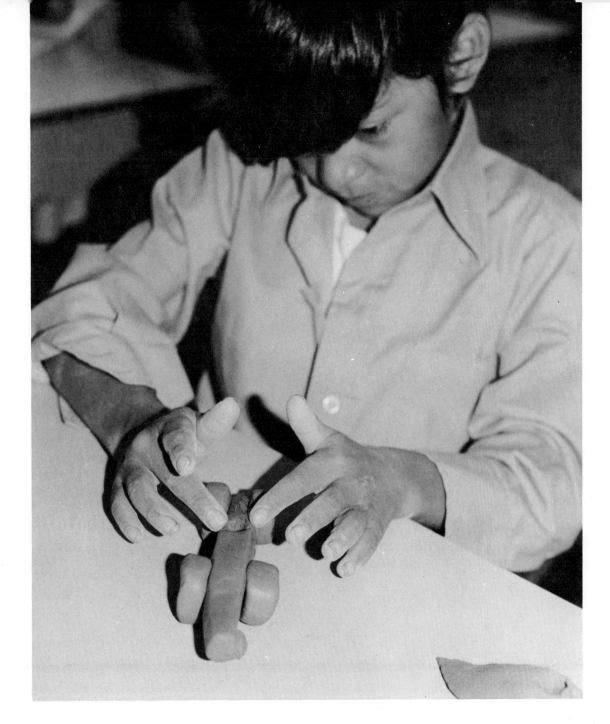

When the car body is finished, put on the wheels. Use matchsticks or nails. A good racing model is as smooth and symmetrical as a bird or a fish.

If you have learned something
from the children in this book,
welcome!

For so have I.

John Hawkinson